ARTIST'S STUDIO

MODERN
ACRYLICS

Featuring Golden Artist Colors and Products

By Patti Mollica

Quarto is the authority on a wide range of topics.
Quarto educates, entertains, and enriches the lives of our readers—
enthusiasts and lovers of hands-on living.
www.quartoknows.com

6 Orchard Road, Suite 100
Lake Forest, CA 92630
quartoknows.com
Visit our blogs @quartoknows.com

Contents

Introduction . 4

Section One: Getting Started

Setting up a Studio . 8

Brushes and Mark-Making Materials 9

Painting Surfaces . 13

Section Two: Acrylic Paints

What are Acrylics? . 18

Mineral and Modern Pigments 22

Expressive Painting Techniques 24

Section Three: Mediums and Additives

Introduction to Gels and Pastes 30

Types of Gels . 34

Types of Pastes . 37

Types of Gessos and Grounds 39

Creating Drawing Surfaces 40

Water Media Effects . 41

Mediums for Keeping Paints Wet 42

Section Four: Innovative Techniques and Projects

Glazing with OPEN Paints and Mediums 46

Acrylic Skins . 49

Digital Transfers . 51

Artists' Gallery . 54

Explore • Create • Play 64

Introduction

Ready to embark on a creative joy ride?

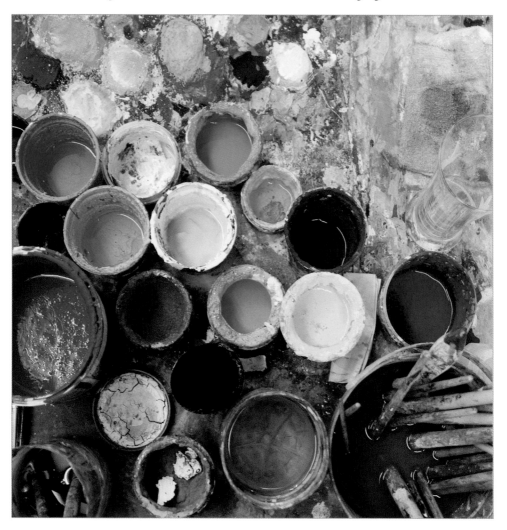

We turn to painting as a path toward creativity and self-expression, as a way to tap our inner soul and give it wings to fly wherever it chooses or needs to go. In my own artistic journey, I have found no better vehicle to take me on this magical journey than acrylic paints and the array of exotic gels, mediums, pastes, and specialty products. To me, these are not simply acrylic products; they are toys just waiting to carry out any creative whims or artistic flights of fancy that I could possibly dream up. And when I open up my acrylic toy box, the sky is the limit—the world drops away, and I step into a delightful expedition that leads me to unknown and unexpected destinations.

I would like to share this world with you by introducing acrylic paints, pastes, and gels. Once you understand how these materials work and become familiar with their properties and characteristics, they will provide you with countless avenues in which to express yourself. You will discover a new world of endless colors, textures, shapes, surfaces, shimmers, and sheens—more eye candy than you can imagine.

More than any other medium I've come across, acrylic materials allow artists to experience uninhibited creativity because the materials work (or rather play) together seamlessly. Unlike other mediums that require knowledge of rules such as "fat over lean" or "dark over light," almost anything goes with acrylic products. A little familiarity with their properties will help you discover new and exciting ways to explore your own vast creative depths. Now let's take that first step and learn all about these amazing and versatile (did I mention FUN?) materials!

Getting Started

- Setting up a Studio
- Brushes and Mark-Making Materials
- Painting Surfaces

Setting up a Studio

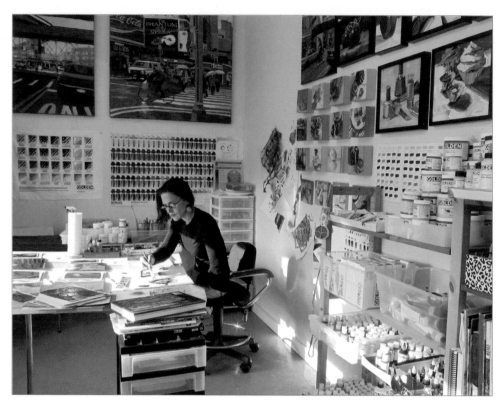

Every artist's dream is to have a large, airy studio with a north-facing window. But the reality is that wherever you can find a place to paint—a spare bedroom, a basement corner, or the kitchen table—is suitable; however, there are a few things to keep in mind that will make your painting experience more pleasant and fruitful.

The space where you paint should be well lit, roomy enough to accommodate an easel or table and chair, and have a place where you can organize and store your supplies. Clip-on lamps (available at your local hardware store) can be used when natural light is not available. If you are working with fluid or less viscous materials, it is best to work on a flat surface so the materials do not run. When using heavy body paints and gels, working at an easel is fine. You will want your supplies within reaching distance. I use several plastic taboret-style units with multiple drawers that stand on rollers for ease of mobility. They also serve as platforms for arranging still life compositions.

Over the years I've found that a workspace, in addition to being functional, should be comfortable and welcoming. I like having inspirational images pinned up around me, such as a corkboard holding samples of art, textures, color combinations, and ideas that get my creative juices flowing.

Brushes and Mark-Making Materials

Paintbrushes

Acrylic paints and mediums can be applied with any brush, including those used for watercolor and oil paints. The bristles come in two types—natural hair or synthetic—and they are available with either stiff or soft bristles. I prefer synthetic brushes for acrylics.

Brushes come in a variety of shapes that result in specific brushstrokes (see page 10). Unless you want every brushstroke in your painting to be one consistent width, it's a good idea to pick up various sizes and shapes.

The basic shapes are:
- Flats – long bristles that are squared off at the top
- Brights – short, squat bristles that are squared off at the top
- Filberts – long bristles that are slightly rounded at each corner
- Rounds – bristles that taper to a soft point at the tip
- Liners – long, soft bristles that taper to a very fine point
- Fans – fan shape that produces a "feathered" stroke for blending

Stiff-bristle brushes are great for working with thick acrylic paints and gels, such as GOLDEN Heavy Body Acrylic Colors. They are coarse and sturdy, which allows them to pick up and deposit a large amount of paint. They often leave a stroke that shows the bristle texture. Soft-hair brushes are great for smoother, more delicate passages of a painting, and they do not leave a visible brush mark texture.

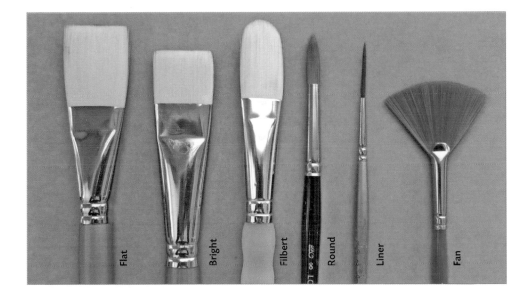

Flat Bright Filbert Round Liner Fan

Whether bristle or soft-hair, a good brush will always "spring back" into shape when wet. This is an important consideration when buying brushes—especially the less expensive brands. Also, when a brush is wet, you want the tip to taper. When hairs are splayed out or do not spring back into shape, it is difficult to paint with any nuance or precision. Be meticulous about cleaning your brushes. Because acrylic paint dries so quickly, it can easily get stuck in the bristles.

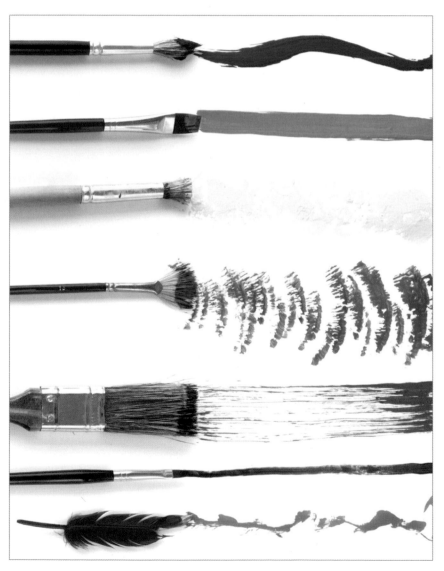

Each brush shape will produce a unique mark. Get familiar with your brushes and the various marks they can produce.

Palette Knives

Palette knives, which are used for mixing paint colors, can also be used to apply paint to your surface. Many artists create paintings using only palette knives; they apply the paint as if they are frosting a cake. This will result in a thicker, richer application of paint and produces a very different look than a paintbrush does. You can apply the paint in this manner using GOLDEN Heavy Body Acrylic Colors. You can also use Fluids if you mix them with a gel or paste.

I prefer metal palette knives with a diamond shape and point at the tip. This allows me to create fine lines and detail, such as branches, sailboat masts, telephone lines, and so on. They are also useful for mixing paint, and you can clean them with one wipe of a towel.

Listed below are additional ways of applying paint. Notice how each tool produces a different effect. Use your imagination and then try out some tools of your own.

- Sponges
- Foam brushes
- Putty knives
- Cardboard strips
- Rubber stamps
- Toothbrushes
- Feathers
- Hair-color bottle applicators
- Eye droppers
- Cake decorating materials

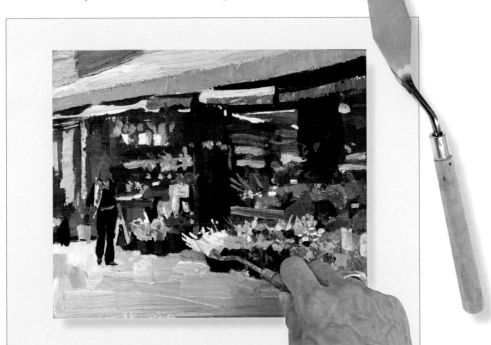

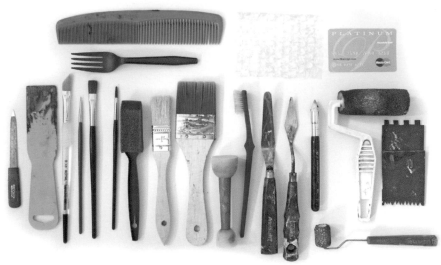

Making Textures and Imprints

Once your paint, gel or paste has been applied to the surface, you can press or imprint a design into it. This works best with thicker paints and gels. This process creates interesting textures that you can stain or wash over with translucent paint mixtures called glazes, which pool and seep into the crevices of the imprint.

- Stencils
- Fabric (cheesecloth, lace, burlap)
- Coins
- Foam or rubber stamps
- Toothbrushes
- Bubble wrap
- Sandpaper

- Tin foil
- Buttons
- Jar lids
- Chopsticks
- Plastic combs or graining tools
- Cookie cutters
- Anything else you can think of (e.g., utensils, household parts, etc.)

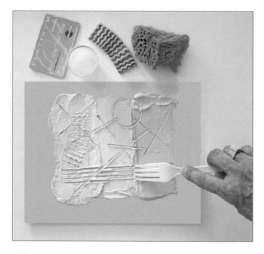

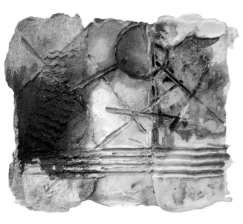

Painting Surfaces

One advantage of acrylic paint is that you can work on many surfaces, also called "substrates." Each surface has a different texture and lends a special effect to your work. The only surfaces that do not accept acrylic paint easily are greasy or oil-based surfaces—do not apply acrylic over oil paint—and slick, hard, non-porous surfaces, such as glass, ceramic, and metal (unless they are pre-treated with special materials). Acrylic paint needs a "toothy," porous, absorbent surface to which it can bind and adhere properly. For this reason, many surfaces must first be primed to accept the paint. The most common primer is an opaque, white, chalky paint called gesso (pronounced "JESS-oh"). Gesso prepares your substrate to accept subsequent layers of paint and gels. The following are several popular acrylic painting surfaces:

Canvas

Canvas is the most popular acrylic painting surface and can be bought primed or unprimed, as well as unstretched in large rolls, pre-stretched on wooden frames, or mounted on panel boards. If you choose unprimed canvas, prepare it by applying two coats of gesso using a large flat brush or a roller. Let dry; then apply another coat perpendicular to the strokes of the first layer.

Canvas Paper

This is commercially prepared paper that simulates canvas texture and weave but is available in pad form. It does not require priming and is less expensive than actual canvas—perfect for practicing new techniques.

Papers and Boards

Many artists paint on watercolor paper, print-making papers (used with inks and printing presses), and Bristol board (available in pads). You can use these surfaces either primed or unprimed. To minimize the buckling and warping of papers, you can tape the sides down to a stable surface, wet the entire paper, and let it dry completely. This "pre-stretches" the paper so that it will retain its flat quality when you paint on it. Another way to minimize buckling is to prime both the front and back of the paper with one or two coats of gesso; then let it dry before beginning your painting.

Many supports have impurities that can discolor a translucent acrylic gel layer or color glaze. These require the application of a sealer before priming to ensure the gel films stay clear as they dry. If you are using layers of gels and want to protect your painting from discoloration, apply three coats of GOLDEN's GAC 100, which is ideal as a sealer. (See "Hardboard and Panels," page 14.)

Traditional painting surfaces:

A. Canvas paper

B. Masonite or hardboard

C. Pre-primed canvas panels

D. Canvas

E. Watercolor paper

F. Primed mat board

Cardboard and Mat Boards

These are wonderful surfaces for painting because they are economical, lightweight, and readily available. Many framers will freely give their leftover mat boards scraps if you ask. These surfaces require two coats of gesso before using.

Hardboard and Panels

Many artists paint on smooth, hard, inflexible surfaces, such as hardwood (oak, cedar, birch, walnut, etc.); medium density fiberboard (MDF) such as Masonite; and plywood. These must be primed with two or three coats of GAC 100 because they contain resins and impurities that can leech up into your painting and cause noticeable discolorations—called Support Induced Discoloration (SID)—especially if you are using transparent gels and mediums.

Rather than painting on a white canvas or paper, use any fabric as a starting point for creating a painting. Add paint, gels, and pastes just the way you would if working on canvas. Use several coats of GAC 100 to prime, if desired.

Prepared Surfaces

When starting new projects, many artists find it difficult to face a blank white canvas. I overcome this by having several surfaces prepared ahead of time with any of the GOLDEN pastes or gels. Sometimes I tint them with color; other times I apply them straight from the jar. I prepare several surfaces at a time, because they will need to dry. Since acrylic products look different from the wet to dry stage, this anticipation lures me back into the studio to see the end results of my experimentation. Trying out new surface variations with pastes and gels is great way to stay inspired!

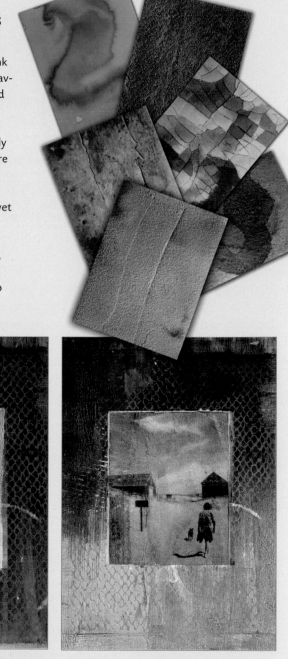

A photograph was digitally transferred onto a Soft Gel (Gloss) skin and applied to a prepared surface. The surface was prepared by using Iridescent and Interference paints overlaid with stamp patterns. (See "Acrylic Skins," page 49.)

Acrylic Paints

- What are Acrylics?
- Mineral and Modern Pigments
- Expressive Painting Techniques

What are Acrylics?

Acrylics burst into the art scene in the late 1950s. These paints offered artists an exciting, revolutionary material in which to carry out their visions and dreams, unbridled by the limitations of the traditional media at the time: oil- and solvent-based paint.

Composition

Acrylic paint is made up of pigment particles (color) suspended in a fast-drying acrylic polymer dispersion, which is also called the "binder." Just as linseed oil is the binder for oil paint and gum arabic is the binder for watercolor, polymer dispersion is the "glue" that holds the pigment in place and adheres it to your surface. This polymer dispersion is made up of two main ingredients: water and polymer solids (tiny plastic spheres). When the water evaporates, the spheres stick together and form a film that dries and traps the pigment in place on your canvas.

This polymer dispersion (binder) is white when wet, but it turns clear and glossy when dry (like glue). As a result, your paint will look lighter when wet and slightly darker when dry. Matte mediums and gels, however, dry with a slightly frosty finish; they will not be perfectly clear.

Versatility

There are a wide range of acrylic products that allow you to customize the sheen, texture, and flow of your paint. If you don't like the naturally glossy character of the binder, you can incorporate one of the matte products into your work. Because each pigment contained in the paint has its own unique qualities (some are inherently matte and opaque, whereas others are transparent and glossy), paint companies generally create formulations that result in a uniform sheen across their entire product line. What makes GOLDEN acrylic colors special is that they don't contain fillers, extenders, opacifiers, or matting agents to change the paints. The result is very highly pigmented colors right from the tube. It is your choice to add products that change the look of the paint to suit your creative vision.

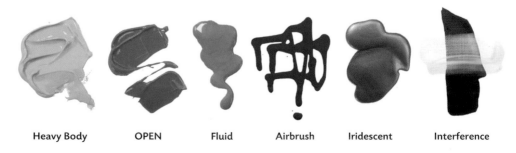

| Heavy Body | OPEN | Fluid | Airbrush | Iridescent | Interference |

Viscosity

Viscosity refers to the relative thickness (high viscosity) or thinness (low viscosity) of the paint. GOLDEN offers a vast array of paints in many different viscosities to suit every artistic need. Let's discuss each one in order of its viscosity, from high to low.

Heavy Body

Heavy Body paint is characterized by an exceptionally smooth, thick, buttery consistency. These paints have the ability to "stand up" and retain brushstrokes or palette knife marks, and they remain extremely flexible when dry.

Fluids

Fluid paints have the consistency of heavy cream. They are self-leveling and do not retain brushstrokes. They load onto brushes easily and flow effortlessly off the bristles with long, uniform strokes. When mixed with medium or water these paints make brilliant glazes and washes. When water is added to Fluid paints, they simulate watercolors—with one big advantage: You can layer one wash on top of another without disturbing what's underneath, provided you let each layer dry before adding the next.

Although Fluid paints have a lower viscosity than Heavy Body paints, their pigment load is extremely high. Some artists think that adding water to Heavy Body paints will produce the equivalent of Fluids. This is not the case. You will get the best results by using the paint and viscosity that suits your needs.

OPEN Acrylics

OPEN paints are so named because their "open time" (or wet time) is approximately ten times longer than regular acrylics. This offers the artist more time for careful blending and detail work normally associated with oil techniques, but without the need for solvents. They are the perfect choice for plein air (outdoor) painters because traditional acrylic paints tend to dry fast in an outdoor environment. OPEN

paints can be used and mixed with any and all of the GOLDEN products. To speed up drying time, simply mix the paints with any other fast-drying paint, gel, or medium.

Airbrush

Airbrush paints have the consistency of ink and can be used in many ways—not just for airbrushing. They are a highly pigmented, light-fast formulation that is perfect for delicate detail, nuanced linework, illustration, and fine-art applications. Because of the virtually clog-free formula, they can be used in technical pens and airbrushes. They are also perfect for glazes and stains.

Iridescent

Iridescent acrylics impart an exciting, highly reflective sheen and offer endless shimmery variations when used alone or mixed with other GOLDEN colors. Iridescents range from gold and silver to bronze, copper, and pearl. Because Iridescent pigments depend on light for brilliance, mixing them with glossy gels and mediums allows more light to surround the pigments and increases their iridescent quality.

There are 20 shimmery shades of Iridescents. The chart at right shows how you can mix any Iridescent (far left column) with any acrylic color (top row) to achieve exotic color variations.

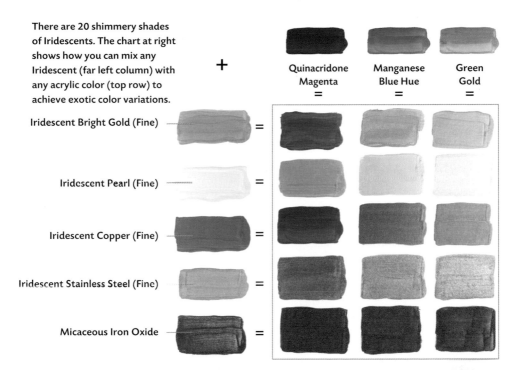

+

	Quinacridone Magenta =	Manganese Blue Hue =	Green Gold =
Iridescent Bright Gold (Fine) =			
Iridescent Pearl (Fine) =			
Iridescent Copper (Fine) =			
Iridescent Stainless Steel (Fine) =			
Micaceous Iron Oxide =			

Interference

Interference paints simulate the most dazzling effects of nature. Examples of this include the amazing colors on butterfly and beetle wings, fish and lizard scales, and in the dramatic swirling colors of an oily slick floating in puddles after a rainstorm.

Here's how Interference paints work: When painted over a dark background, the Interference color will appear and shimmer brilliantly. When painted over a light-colored background, its complementary color will appear. This is the fascinating "flip" effect of Interference paints that occurs when light waves are reflected and refracted. Because Interference paints have no pigment particles, you can mix them with any color, and they will not get muddy.

Mineral and Modern Pigments

Pigments are what make paints colorful, and they come in a wide array of hues (reds, greens, blues, browns, etc.). Pigments also come in two classifications: mineral (inorganic) and modern (organic). Although they share some similar characteristics, their makeup and behavior are different. Mineral pigments have earthy sounding names, such as sienna, ochre, cadmium, cobalt, and ultramarine. Modern pigments have names that allude to their chemical origins, such as quinacridone, phthalo, hansa, dioxazine, and anthraquinone. Knowing their unique characteristics will help you make accurate color-mixing choices.

Mineral pigments are generally characterized by:
- high opacity (very opaque)
- low chroma (less vibrant)
- low tinting strength (do not strongly change the colors they are mixed with)

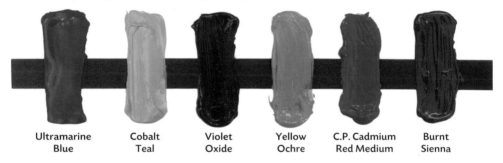

| Ultramarine Blue | Cobalt Teal | Violet Oxide | Yellow Ochre | C.P. Cadmium Red Medium | Burnt Sienna |

Modern pigments are generally characterized by:
- high translucency (very transparent)
- high chroma (very vibrant)
- high tinting (strongly change the colors they are mixed with)

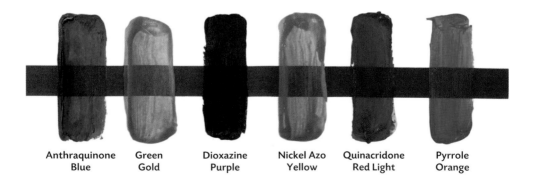

| Anthraquinone Blue | Green Gold | Dioxazine Purple | Nickel Azo Yellow | Quinacridone Red Light | Pyrrole Orange |

Use minerals if you want to layer one color over another without seeing the layer underneath; use moderns if you want to layer colors and allow the bottom-most colors to show through and influence the upper layers.

It is possible to achieve a wide spectrum of colors by mixing only the three primary colors: red, yellow, and blue (plus white). The color wheels below show which hues result from using mineral or modern pigments. Depending on your preferences, you can control the hues in your painting by choosing the type of pigments that suit your artistic vision.

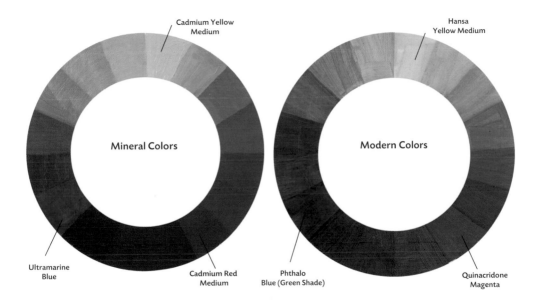

Cadmium Yellow
Medium

Hansa
Yellow Medium

Mineral Colors

Modern Colors

Ultramarine
Blue

Cadmium Red
Medium

Phthalo
Blue (Green Shade)

Quinacridone
Magenta

Keep in Mind

• You are not limited to choosing one or the other—you can mix mineral and modern colors together to achieve greater color subtleties and nuances.

• Because GOLDEN paints are professional-grade artist colors, you will always get the highest ratio of pigment to binder in your paint. Student-grade paints have fillers and extenders that make even the mineral pigments more translucent and weaken the vibrancy of the modern hues. When it comes to paint, you get what you pay for!

Expressive Painting Techniques

Artists are frequently identified by the painting techniques they employ. For example, the richly textured, vigorous brushwork of Vincent van Gogh is quite different from the flat, graphic technique of Henri Matisse. How you apply your materials becomes a significant trademark of your unique artistic expression. Whether you decide to paint representationally or abstractly, you can try different techniques to find the one that feels comfortable and suits your style.

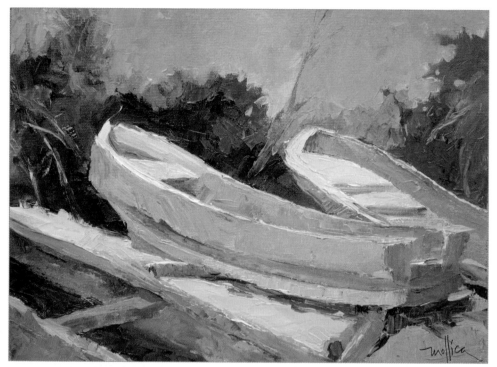

Mexican Boats **by Patti Mollica**

Knife Painting

Many artists use a palette knife to apply their paint. The result is different than brush application because the paint goes on thicker and results in a built-up, textural effect. The colors also retain their brilliance because the application is direct, with less chance of the brush bristles mixing colors together.

Stippling or Pointillism

This is also called the "broken color" technique, which involves using dots or short strokes of color side by side to create the illusion of a third color. Seen from a distance, the different colors blend optically. For example, if you put strokes of blue adjacent to strokes of yellow in a random pattern, the colors will "mix" and appear green to the viewer.

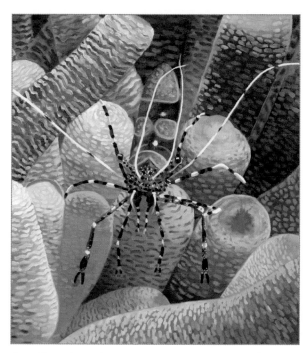

Clown Shrimp by Mark Hagan

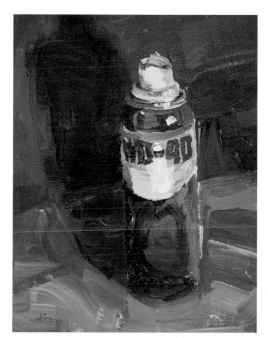

WD-40 by Patti Mollica

Impasto

Impasto is a method of applying thick paint in which the brush strokes or knife marks retain their shape. With its thick, buttery viscosity, GOLDEN Heavy Body Acrylic paint is a perfect choice for the impasto method. You can also add Heavy, Extra Heavy, or High Solid Gel with your paint for even heavier viscosity and a sculptural effect.

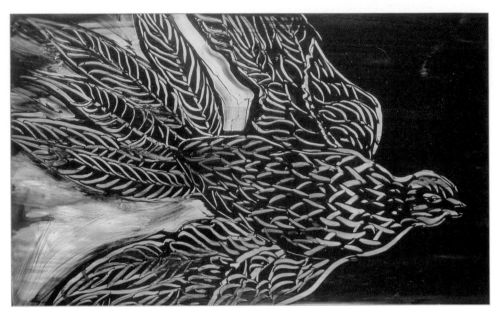

In Flight by Patti Brady

Sgraffito

The term Sgraffito comes from the Italian word *sgraffiare,* which means "to scratch." This method involves scratching through a layer of wet paint to expose the underlying colors beneath. You can use almost any object to create this effect—the end of a brush handle, a chopstick, or a palette knife. GOLDEN Fluid paint mixed with one of the heavy gels is a great way to explore this technique.

Glazing/Washes

This is a method of applying translucent colors in succession. Each layer of paint is allowed to dry fully before another layer of translucent color is applied. Each glaze adds its own color yet is influenced by the colored layers underneath it. These produce a rich, transparent, glowing effect. This method is achieved successfully by using modern colors thinned with Polymer Medium (glaze) or water (wash).

Tiger Cowrie by Mark Hagan

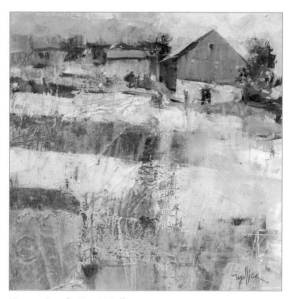

Upstate Barn by Patti Mollica

Drybrush

As the name suggests, this technique involves loading thick paint onto a dry brush and lightly dragging it over a dry textural surface. The paint "catches" on the raised texture of the surface, which results in a broken, scratchy effect, revealing little speckles of the under layer.

Traditional

Traditional painting methods place an emphasis on realistic depictions of the subject matter. This requires blending colors and values in a soft, graduated manner. GOLDEN OPEN Acrylics, when used with OPEN Acrylic Medium and OPEN Thinner, enable paints to stay wet (or open) for longer periods of time.

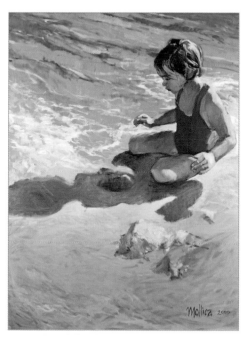

Caroline by Patti Mollica

Mediums and Additives

- Introduction to Gels and Pastes
- Types of Gels
- Types of Pastes
- Types of Gessos and Grounds
- Creating Drawing Surfaces
- Water Media Effects
- Mediums for Keeping Paints Wet

Introduction to Gels and Pastes

Gels and pastes are the "secret" ingredients that will allow you to take your creative ideas and explorations to new heights. Golden Artist Colors offer many gels, pastes, and grounds that can be used alone, together, or layered in any combination and mixed with any of the paints; therefore, the opportunity to explore countless avenues for personal expression is right at your fingertips. Finding "your voice," artistically speaking, has never been so easy and so much fun.

These materials are all made of the same ingredients: water and acrylic polymer solids. For you, this means creative freedom. You can mix, layer, and combine them in any way you wish to create endless variations and spectacular effects. The fast dry time lets you "layer up" to your heart's delight. Unlike oils, which have oppressive rules and dry times, acrylics allow you to follow your musings without fear of improper application techniques.

Gels can be thought of as colorless paint—they are made from binder but contain an added swelling agent to give them a heavier viscosity. They are offered in gloss, semi-gloss, and matte sheens and in viscosities ranging from light and (almost) pourable (like yogurt) to extra heavy (like peanut butter). Pastes are gels with solids added (marble dust, calcium carbonate, glass beads, etc.). This gives them body, which results in interesting textures and sculptural effects. Mediums are a low-viscosity polymer that you can use to thin paint for a better flow and to create glazes.

Light Molding Paste Clear Tar Gel High Solid Gel (Matte) Coarse Pumice Gel Regular Gel (Matte)

Crackle Paste Coarse Molding Paste Extra Heavy Gel (Gloss) Clear Granular Gel Fiber Paste

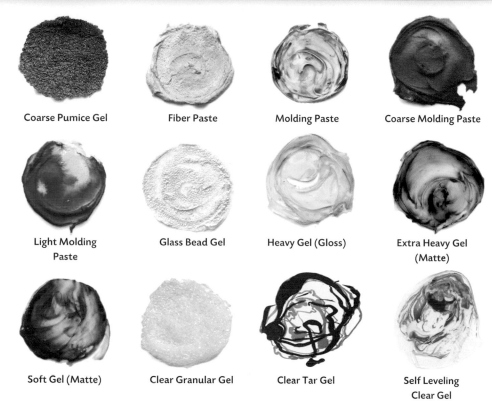

Coarse Pumice Gel	Fiber Paste	Molding Paste	Coarse Molding Paste
Light Molding Paste	Glass Bead Gel	Heavy Gel (Gloss)	Extra Heavy Gel (Matte)
Soft Gel (Matte)	Clear Granular Gel	Clear Tar Gel	Self Leveling Clear Gel

When tinted with color, the unique qualities of the gels and pastes becomes more apparent.

A Note about Layering and Dry Time

All GOLDEN gels, pastes, and mediums can be applied as thin films or layered upon each other for a multi-dimensional effect. It is generally optimal to let each layer dry before applying the next. These products are approximately 50 percent water, so dry time will depend on how long it takes the water to evaporate. Several important factors will influence the evaporation rate, including surface absorbency, humidity, layer thickness, and air flow.

You can use all gels and pastes in the following ways:
- As a surface texture on which to paint (called a ground)
- Mixed with paint for added body and sheen (called as a medium)
- Applied on top of your painting for a covering effect

As a GROUND:

Scoop out some gel or paste with a palette knife and spread it onto your canvas or painting surface. You can either tint it with color or use it straight out of the jar. When it's dry to the touch, start applying your paint, either full strength for bolder color or as a wash or glaze for softer, more translucent effects.

Right: Fluid paint used as a wash applied to a Fiber Paste Ground.

As a MEDIUM:

Scoop out some gel or paste onto your palette or mixing area. Squeeze a few drops of Fluid, Airbrush, or Heavy Body paint into the gel or paste.

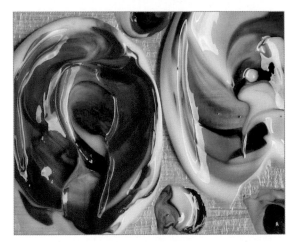

Right: A few drops of Fluid paints swirled into Soft Gel (Gloss) allows the colors to glide and create beautiful patterns.

As a COVER:

Spread a layer of gel or paste onto your painting. Gels are clear and will provide a clear or translucent coating when dry. Pastes are opaque and will cover your painting. Be aware that clear gels can yellow over time. Applying a UVLS varnish over the gel can lessen discoloration significantly.

Right: Glass Bead Gel applied in a thin coat over dry colors produces a frosty, shimmery effect.

The gels are white when they are wet, but they dry clear. Gels range from smooth and creamy, to gritty and rough, to thin and drippy.

The pastes are opaque, both in wet and dry states. Their colors range from white to gray, and they tint any color with which they mix.

All the paints are suitable for mixing into the gels or pastes, but the lower-viscosity paint colors—Fluids and Airbrush—will mix most easily into the higher-viscosity gels and pastes. Also, the translucent (modern) colors will yield rich transparencies when mixed with the glossy gels for a stunning "stained glass" result. You can also layer one translucent color over another, allowing each layer to dry before applying the next.

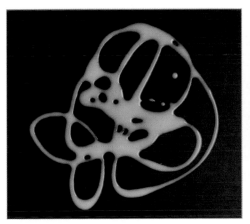

Gloss Gel wet

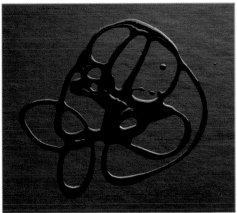

Gloss Gel dry

Keep in Mind

• You can add any GOLDEN acrylic paints to the gels, pastes, and grounds for beautifully toned surfaces, or you can leave them in their natural white, gray, or clear states.

• The modern colors in the Fluid line of paints work especially well for stains and washes on textured surfaces. Their low viscosity and inherent translucency enhances the textural qualities of the grounds.

• Any of the paints, gels, or pastes can be combined and layered in any order for endless unique variations.

Types of Gels

Soft Gels
(Gloss, Semi-gloss, or Matte)

Thinner than GOLDEN Heavy Body Acrylic Colors, Soft Gels are somewhat pourable and have the consistency of yogurt. Soft Gels are recommended to function as a glue for collaging.

Regular Gel
(Gloss, Semi-gloss, or Matte)

Regular Gel has the same creamy consistency as GOLDEN Heavy Body Acrylic Colors and holds moderate peaks and texture. It's ideal for glazing and creating transparent effects.

Heavy Gels
(Gloss, Semi-gloss, or Matte)

Heavy Gels have a thicker consistency than GOLDEN Heavy Body Acrylic Colors. Blend with colors to increase body and add volume. It's ideal for sgraffito techniques.

Extra Heavy Gels
(Gloss, Semi-gloss, or Matte)

Extra Heavy Gels have the consistency of peanut butter. These are some of the thickest of the GOLDEN gels. Blend with colors to increase body and add dimension.

High Solid Gel
(Gloss and Matte)

High Solid Gels are the thickest gels. They dry faster with 25 percent less shrinkage because they contain more acrylic solids (and less water). The matte gel yields a waxy effect. Blend with colors for a sculptural effect.

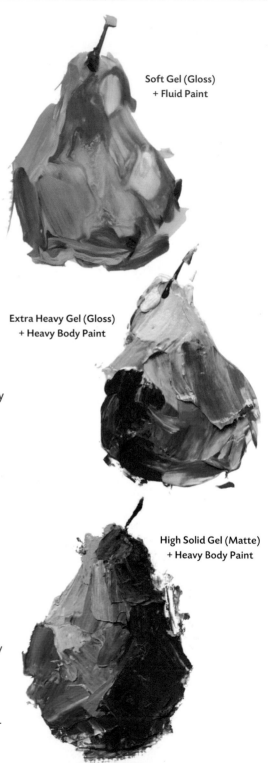

Soft Gel (Gloss)
+ Fluid Paint

Extra Heavy Gel (Gloss)
+ Heavy Body Paint

High Solid Gel (Matte)
+ Heavy Body Paint

Self Leveling Clear Gel

Self Leveling Clear Gel was designed to produce an even, level film with excellent clarity. This product dries to a flexible, high-gloss film, which can increase the transparency and sheen. It's ideal for producing glazes with no evident brushstrokes.

Clear Tar Gel

Clear Tar Gel has an extremely resinous and stringy consistency, which makes it useful for generating fine, detailed lines by "dripping" it over surfaces. It best blends Fluid paints. (Tip: Mix 2-3 drops of color for a stringy effect; do not stir vigorously.)

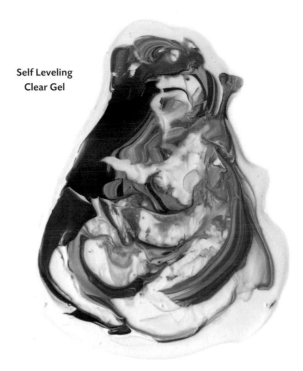

Self Leveling Clear Gel

Textural Gels

These gels have various added materials, which give them a distinct and exciting textural quality.

Pumice Gel – Fine, Coarse, and Extra Coarse

Pumice Gels are used to create textured surfaces. They dry to a hard film. To increase their flexibility, mix with other GOLDEN gels or mediums.

Glass Bead Gel

Glass Bead Gel is a coarse, textured medium with a heavy-body viscosity that holds peaks. Made with genuine glass beads, its unique visual effect—

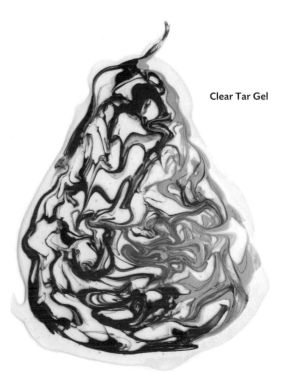

Clear Tar Gel

35

Extra Coarse Pumice Gel

Clear Granular Gel

like that of condensation on cold glass—is best seen in thin films that illuminate the glass beads. To enhance its luminous effect, use transparent (modern) pigments to glaze or stain. For a shimmery, pebbled look, apply a thin layer of gel over a painted surface.

Clear Granular Gel

This gel contains irregular chunks of plastic acrylic. It creates textured surfaces and dries to a hard film. When dry, it has the appearance of little chunks of ice. If you want to enhance the luminous effect of Clear Granular Gel, use it with transparent (modern) pigments in a glazing or staining manner. You can also apply it over a painting for a reflective, "chunky" effect.

Glass Bead Gel

Types of Pastes

Pastes create opaque surfaces and will tint the color you mix into them.

Extra Heavy Gel/Molding Paste

This is a blend of Extra Heavy Gel (Gloss) and Molding Paste. It dries to a satin, semi-opaque finish and is excellent for increasing viscosity and building surfaces.

Molding Paste

Molding Paste is a thick gel mixed with a finely ground marble dust. The marble imparts a hardness to the dry surface and adds a bit of weight. Molding Paste dries to a hard yet flexible white film. It is excellent for building surfaces and creating textures.

Hard Molding Paste

Hard Molding Paste also dries to an extremely hard, inflexible opaque film. Like Molding Paste, it is also used for creating tough, durable finishes. Once dry, it can be carved with hand or power tools. (Always use a mask when sanding.) Other molding pastes should not be sanded or used with power tools, as they soften with friction.

Light Molding Paste

Light Molding Paste is 50 percent less dense than GOLDEN Molding Paste. This results in a significantly lighter film, which is beneficial in creating artworks that are large in size, have thick film build-up, or both. The product dries to an opaque, absorbent, matte finish. It is designed to hold stiff peaks, and its finish is perfect for soft transitions and watercolor effects.

Molding Paste

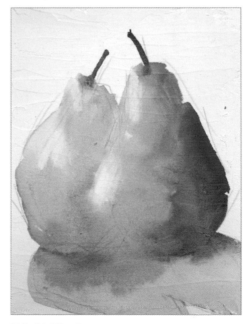

Light Molding Paste

Coarse Molding Paste

Fiber Paste

Coarse Molding Paste

Coarse Molding Paste is a thick, warm, white-colored medium that is translucent up to about $\frac{1}{8}$ inch. It dries to a hard surface and creates a stiff but flexible film with a tooth similar to fine sandpaper. The dry film accepts wet and dry media very well. Mix with GOLDEN Fluid Acrylic Colors or GOLDEN Heavy Body Acrylic Colors to create a dense-feeling paint that holds good peaks and dries with a matte to satin sheen with a finely pebbled surface.

Fiber Paste

This medium offers a surface that has the appearance of rough handmade paper. Skimming the product with a wet palette knife can make a smoother surface. When dry, it has an off-white color and is very absorbent, making it ideal for use with acrylic and watercolor washes or inks.

Crackle Paste

Crackle Paste is a thick, opaque paste designed to create fissure-like cracks as it dries. The size and extent of the crackle pattern is dependent on the thickness of application. The thicker the layer, the deeper and bigger the cracks. Keep layers thin for a more delicate, spider-like cracking pattern.

Crackle Paste

Types of Gessos and Grounds

Gesso (White and Black)

Most artists prepare their painting surfaces with an opaque, absorbent ground called gesso, which seals, protects, and gives "tooth" to your painting surface and promotes good paint adhesion. It is formulated to accept a wide variety of painting and drawing materials on many commonly used painting surfaces. Gesso can be thought of as the "first" foundational ground, upon which other grounds can be applied.

Absorbent Ground

This ground's properties are similar to painting on watercolor paper. It is an opaque, white acrylic liquid that dries to a porous, smooth, paper-like surface. It allows for wonderful staining and watercolor effects.

Acrylic Ground for Pastels

This is an acrylic ground that can be applied to canvas and other supports, allowing them to accept pastels, colored pencil, graphite, and various drawing media. It provides a tooth similar to papers designed for pastel and charcoal.

Silverpoint / Drawing Ground

This white liquid ground is used for the preparation of supports for drawing media. It will produce fine, delicate lines when using a metal stylus, such as a paper clip or nail.

Absorbent Ground

Acrylic Ground for Pastels

39

Creating Drawing Surfaces

Although the GOLDEN products shown here work perfectly with paints, they perform equally as well as grounds for colored pencil, graphite, pastel, charcoal, conté crayon, and more. No more running to the store to buy a certain color of pastel paper. Simply tint your favorite paste in the exact color you want, let it dry, and draw away. How perfect is that?

Micaceous Iron Oxide tinted with Fluid C.T.
Interference Blue Green

Fiber Paste tinted with Sap Green Hue

Coarse Molding Paste tinted with
Fluid Manganese Blue Hue

Acrylic Ground for Pastels
over a stripe of Vat Orange

Fine Pumice Gel tinted with
Fluid Indian Yellow Hue

Silverpoint/Drawing Ground
inscribed with a metal nail

Water Media Effects

Just as you can draw on these amazing surfaces, you can also create washes. Thin your paints and let them take on the dreamy, soft quality of watercolors. Fluid or Airbrush paints are the best choice for this style.

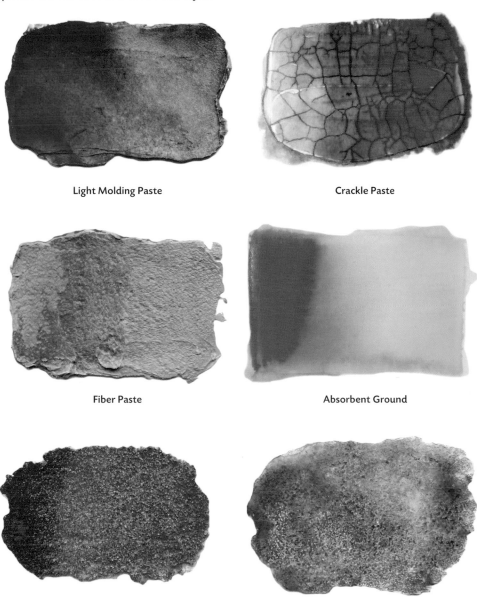

Light Molding Paste

Crackle Paste

Fiber Paste

Absorbent Ground

Coarse Pumice Gel

Glass Bead Gel

Mediums for Keeping Paints Wet

Many artists think of acrylic paintings as having a hard-edged look. For this reason, many have turned to oils in order to blend and soften edges. But this changed with the introduction of GOLDEN OPEN acrylics. OPEN paints and mediums stay wet about ten times longer than regular acrylics, which gives artists more time for blending, glazing, and creating fine detail.

OPEN gels and mediums are versatile and fully compatible with all GOLDEN paints and products. You can blend the faster- and slower-drying paints and mediums in ratios that suit your needs and time frame. Many artists use regular paints for the *imprimatura* (underpainting) stage and gradually add OPEN paints and medium as they move to finishing stages that require careful blending and soft transitions. OPEN products are perfect for plein air painting as well as printmaking, especially monoprints. Although they dry slow, they clean up fast with soap and water. It doesn't get much easier than that!

OPEN Acrylic Medium (Gloss and Matte) is a low-viscosity medium used to extend and increase the flow of paint.

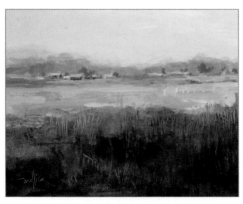

I took to the fields on a hot, sunny day and worked with GOLDEN OPEN Acrylic Paints, Medium, and Thinner in plein air to create this pastoral scene. I was able to create soft glazes of atmospheric perspective in the background, while using a sgraffito technique in the foreground. This would have been impossible with fast-drying acrylics.

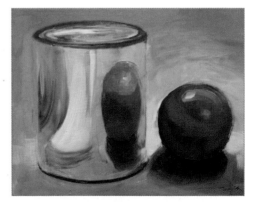

I created this painting using GOLDEN OPEN Acrylic Paints, Medium, and Thinner. Notice the soft blending and nuanced edges I was able to achieve because of the extended dry time.

OPEN Thinner contains no binders and is used to thin the consistency of paint. Use it to maintain and adjust the workability of colors on your palette without the use of a water mist.

Acrylic Glazing Liquid (Gloss and Satin) is also a low-viscosity medium designed to give you a longer working time than regular acrylic mediums; however, it's not quite as long an OPEN medium. It is ideal for creating glazes and improving paint flow.

One Paste, Many Techniques

In addition to using pastes and gels as surface textures, it's fun to incorporate them into your artwork in other ways. Below are a few ways to use these, but there are many. Play with them to create your own variations!

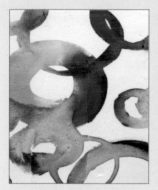

Light Molding Paste used as a ground for washes with Fluid paints.

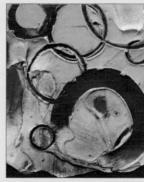

Light Molding Paste used to create a sgraffito effect.

Light Molding Paste used as a ground for drawing with pastels and colored pencils.

Light Molding Paste skin painted with Fluid washes. (See "Acrylic Skins," page 49.)

Light Molding Paste used as a stencil by painting over the open parts with Fluid paint. (See "Skins as Stencils," page 50.)

Light Molding Paste used as a wet ground and painted on in a wet-on-wet manner.

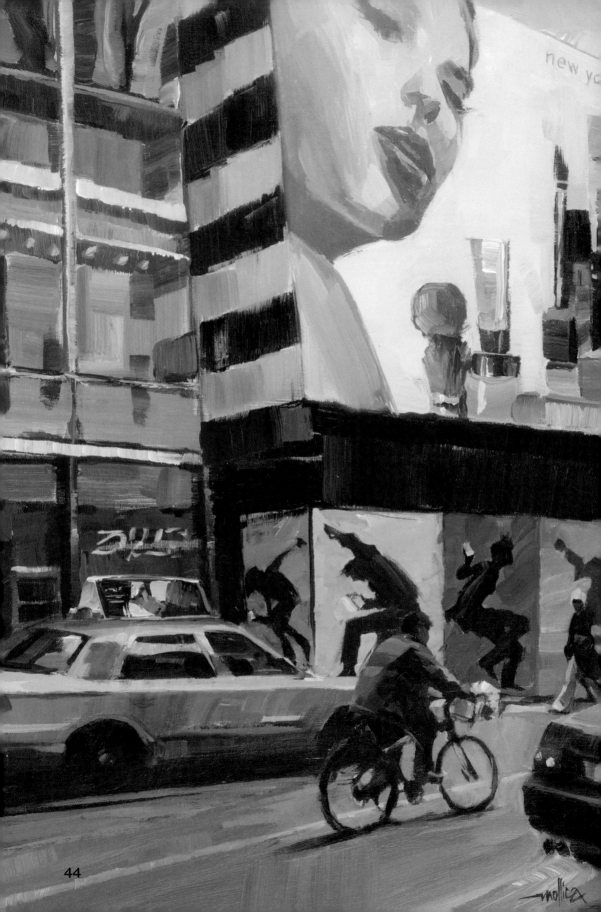

new yo

44

SECTION FOUR

Innovative Techniques and Projects

- Glazing with OPEN Paints and Mediums
- Acrylic Skins
- Digital Transfers
- Skins and Transfers
- Artists' Gallery

You've learned all of the acrylic paint basics. Now it's time to put that knowledge to use. Let's create some art!

This exercise will introduce you to the glazing technique, which involves working with translucent colors in layers. Many of the Old Masters such as Vermeer and Leonardo da Vinci created paintings using colored glazes applied over a dry, black-and-white tonal underpainting, called a *grisaille* (pronounced griz-EYE).

STEP ONE Using GOLDEN Soft Gel as a collaging "glue," mount a black-and-white inkjet or laser print photo to your painting surface, image side up. Smooth out bumps and air pockets with a putty knife or credit card. Let it dry completely; then apply a layer of Polymer Medium (Gloss) over the entire surface. Let dry.

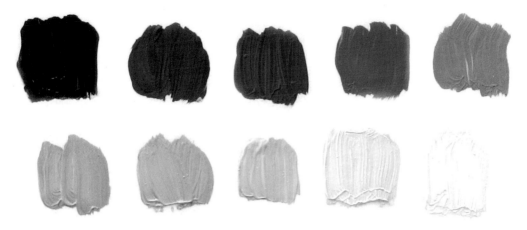

STEP TWO Using OPEN titanium white and carbon black, mix 10 small gray shades, ranging from very dark to very light. Mix enough paint for each shade, depending on the size of your painting.

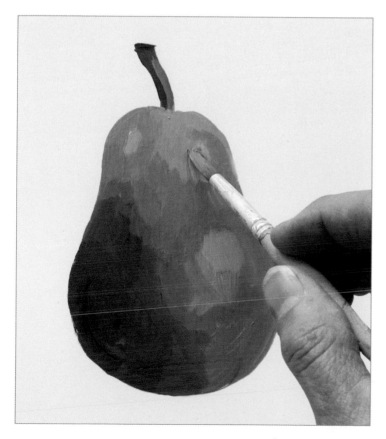

STEP THREE Paint on the photo, carefully matching the gray tones you see. Match them as closely as possible. Blend and create soft transitions between the light and dark values. Let dry completely.

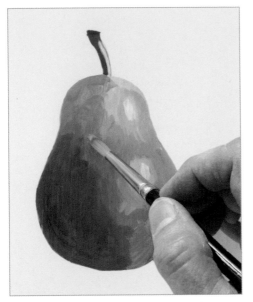

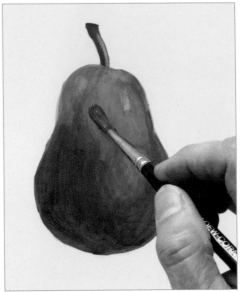

STEP FOUR Using OPEN acrylic colors and OPEN Medium and Thinner, paint over the image using glazes. A glaze is approximately 10 percent color mixed with 90 percent medium. Don't worry about exact ratios—your goal is to create translucent colors and to layer them one on top of another. Each successive color will be influenced by the colors underneath it. In this example, I used nickel azo yellow, quinacridone nickel, azo gold, turquoise (phthalo), hansa yellow medium, alizarin crimson hue, sap green hue, and zinc white.

STEP FIVE Continue until you achieve the color and richness you desire. Paintings created through this glazing technique are known for their luminous quality.

Acrylic Skins

When paints, gels, mediums, pastes, and grounds become dry, they form a flexible film called a "skin." If you apply any of these products to a nonbinding surface, you can actually peel them up off the surface and use them as collage materials. They can be incorporated into your painting by adhering them in place with GOLDEN Soft Gel, Polymer Medium, or Regular Gel. A good rule of thumb is to use the viscosity that matches the weight of your collage element. For example, Polymer Medium for paper or Heavy Gel for cardboard.

Making skins is easy. Simply apply a paste, paint, gel, or medium to your nonbinding surface. Let it dry completely; then peel up and adhere onto your art. Acrylic products adhere easily to each other, so take care to keep your skins separate until you are ready to use them.

Some examples of nonbinding surfaces include wax paper, freezer paper, garbage bags, plastic sheet protectors, glass, or high density polyethylene (HDPE) plastic.

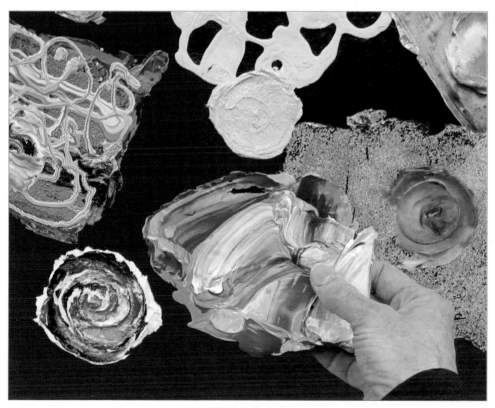

Here are various skins created from paints, pastes, and gels. They are interesting elements to integrate into your paintings.

Skins as Stencils

You can collage these interesting elements into your artwork, but it's also easy to use skins as stencils. Once they dry, lay them on your artwork and paint over them with a brush, roller, or sponge for interesting patterns.

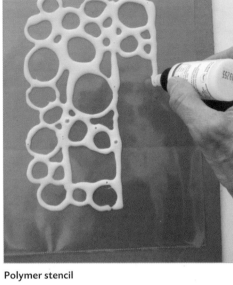

Polymer stencil

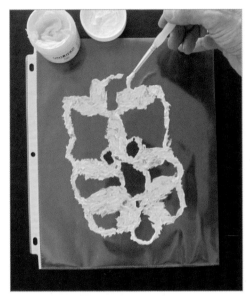

Fiber Paste stencil

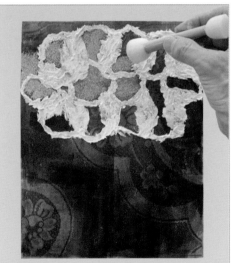

Painting through a Fiber Paste stencil

GOLDEN
M E D I U M S
Polymer Medium (Gloss)

Useful for creating glazes, enhancing gloss, lowering viscosity and increasing flow and leveling of all GOLDEN Acrylic Colors.

Made in USA
#3510-6
16 fl. oz. / 473 ml

GOLDEN
GEL MEDIUMS
Fiber Paste

Pâte à fibres/Faserpaste/Pasta de fibra
A flexible, rough film with a homemade paper appearance. Use as a texture or as a ground on canvas or board. Skim with a wet palette knife for a smoother surface. Use alone or blend with GOLDEN Acrylic Colors

GOLDEN #3240-5 NET 8 fl. oz. / 237 ml

Made in USA

Digital Transfers

Digital Transfers

Ever wish that you could somehow incorporate traditional and digital images into your paintings? Now you can. By coating your surfaces with GOLDEN Digital Grounds, you can run many types of substrates through your inkjet printer, including canvas, handmade papers, acrylic skins made from many GOLDEN products, fabrics, and even thin metals like tin foil. (Note: These products are not intended for use with laser printers.) GOLDEN Digital Grounds are ink-receptive coatings intended for use with inkjet printers. Once applied, you can print photos, artwork, and designs, which can be collaged and integrated into your artwork.

There are three types of grounds, all of which are water based. Choose the appropriate ground for the surface on which you are printing.

Digital Ground Clear (Gloss) – A clear gloss ground for use on porous or absorbent materials where clarity is desired to see the underlying surface.

Digital Ground for Non-Porous Surfaces – A clear gloss ground for coating non-porous surfaces, such as dried acrylic paint, plastic, and metal foils.

Digital Ground White (Matte) – An opaque white ground suitable for printing onto a large variety of porous and non-porous surfaces. The smooth, absorbent surface allows printing inks to dry rapidly. If you are printing on dark paper, this will allow your image to display easily.

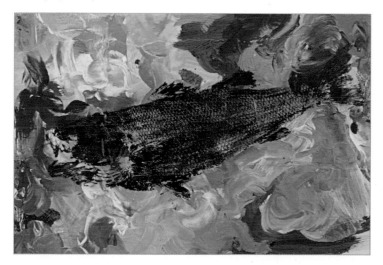

This image was printed on a clear skin made from Soft Gel (Gloss) using Digital Ground for Non-Porous Surfaces. I chose a clear surface so the colorful background would show through.

Working with Skins and Digital Transfers

Follow the steps below to prepare your surfaces for digital transfer printing.

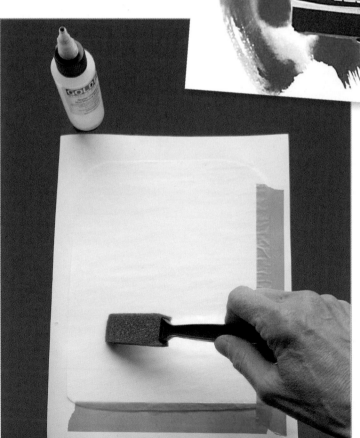

STEP ONE Select the digital image you want to print.

STEP TWO Use Soft Gel to create an acrylic skin. (See "Acrylic Skins," page 49.) Use low-tack artist's tape to adhere the skin to a piece of regular paper. Coat skin with Digital Ground for Non-Porous Surfaces using a foam brush. Apply two coats, each in an opposite direction. Let each dry thoroughly.

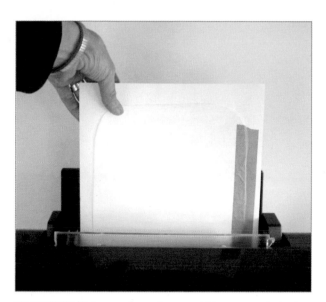

STEP THREE Make sure the surface on which you are printing is cut to a size smaller than your carrier sheet. Place the carrier page squarely in the printer feeder, and print the image.

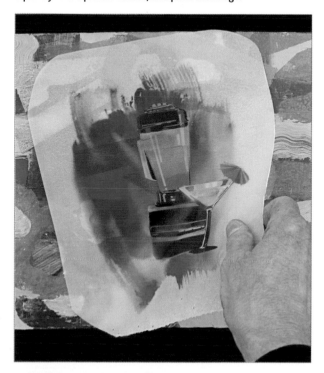

STEP FOUR Your digital transfer is now ready to be integrated into your painting.

Printers and Paper Paths

Not all printers support printing on thicker, textured surfaces. It's important to note the path of the paper when it feeds through the printer. There are two recommended types of paper path. The first type is an **L-shaped path,** wherein the paper from the tray feeds from the back of the printer, bends gently as it enters the print area, and emerges straight out the front. This paper path supports substrates that are flexible and thin, such as specialty papers and thin paint skins. The other recommended printer is one with a **straight-through path** wherein the paper feeds from the back and emerges straight through to the front, or the paper feeds from the front and positions the substrate at the back. (This is the preferred paper path.)

For more information on working with inkjet printers, tips for printing digital images on various substrates, and instructional videos, visit www.goldenpaints.com/mix-moremedia/index.php

Here are how some professional artists have used acrylics in their works. Feel free to use these ideas as a starting point from which to develop your own ideas.

Using Heavy Body Paint in a Loose, Abstract Manner
with Patti Mollica

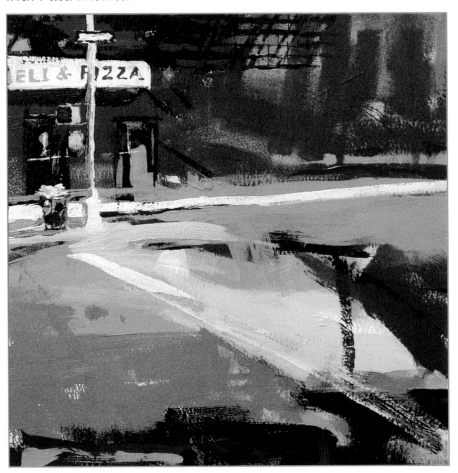

Tribeca Corner • 18x18" Acrylic on panel • By Patti Mollica • www.mollicastudio.com

Using Fiber Paste and Light Molding Paste for my ground, I painted toned washes over large areas. When that dried, I scumbled over the textured ground with several pre-mixed Heavy Body colors. I used brushes and applied paint thickly. My goal was to use actual scenes as a springboard to play with shapes and colors, rather than to record detail.

Layers, Pours, and Paints

with Patti Brady

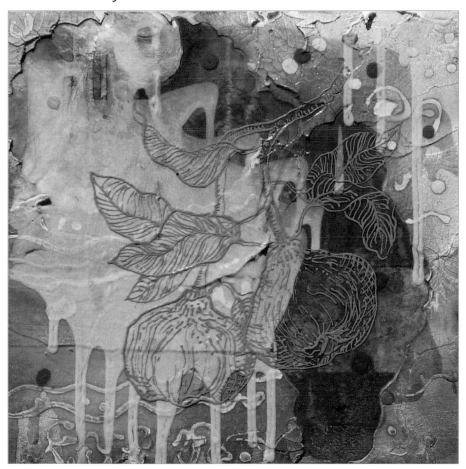

Pink Pears • **10x10"** Acrylic on wood panel • By Patti Brady • www.pattibrady.com

I started out using numerous glazes of Polymer Medium tinted with Fluid paints. When they were dry, I placed stencils down and applied tinted Crackle Paste over certain areas, lifting up the stencil before it dried. I mixed a few drops of Fluid paint and water with Acrylic Ground for Pastels; then I poured the mixture over the painting. I then painted fruit in a linework style with a fine brush.

Creating Depth with Clear Gels and Fluids

with Adria Arch

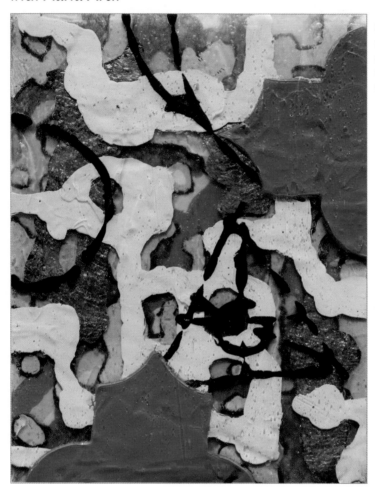

Untitled
5x8" Acrylic
on paper mounted on board
By Adria Arch
www.adriaarch.com

I sealed my wood surface with three coats of GAC 100 to prevent discoloration in the clear gel layers. I then applied layers of Clear Tar Gel. When they layers were dry, I painted various patterns with Fluid paints. The build of Clear Tar Gel layers with painted forms created a sense of depth. Using Molding Paste mixed with Fluid paint, I stenciled on some shapes to create the final layer.

Using Complements for a High-Energy Effect

with Soraya French

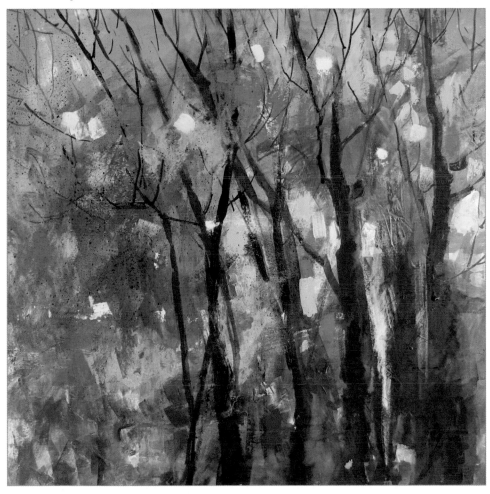

Autumn Colors • 12x12" Acrylic mixed media on hardboard • By Soraya French • www.sorayafrench.com

To create texture, I started by pasting pieces of tissue paper to my surface with Soft Gel (Gloss). I then dabbed some small patches of gesso in several areas where I wanted light spots. I developed the painting using thick layers of Heavy Body paints and Fluid paint washes and glazes. I worked with a complementary palette of cool blues and warm oranges.

Imprinting Texture into Gels

with Teyjah McAren

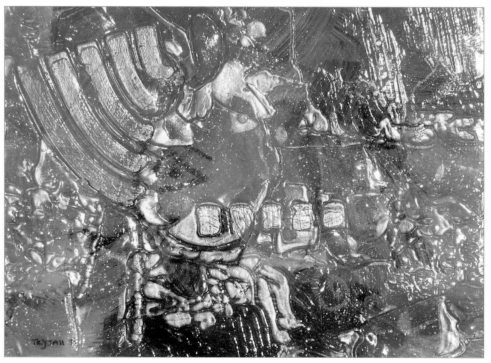

Canyon Passage V • 6.5x8" Acrylic gel and iridescents on board • By Teyjah Mc Aren • www.teyjah.com

I started out by painting washes of Fluid paints on mat board that was primed with several coats of gesso. I then applied a thick layer of Heavy Gel (Gloss). While it was still wet, I imprinted textures and shapes into the gel with various utensils and objects. I diluted Fluid Iridescent paint with water and, with the gel still wet, poured it over the top of the surface. I then allowed the painting to dry and scumbled additional colors over the raised areas.

Gel Transfer and Paint Collage

with Bonnie Cutts

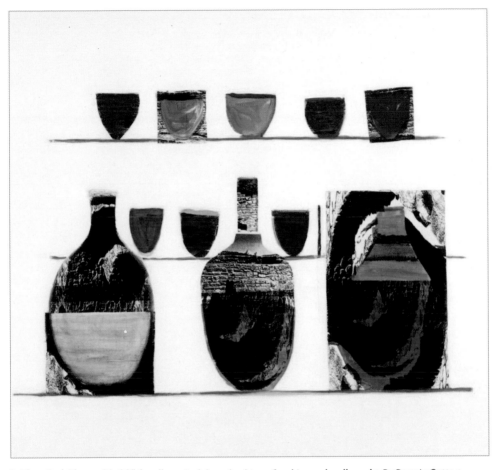

In There Back There • 30x30" Acrylic materials and gel transfer skins on hardboard • By Bonnie Cutts •
www.bonniecutts.com

I created a skin using Regular Gel (Gloss) and then made a digital transfer of a high-contrast black-and-white photo. I cut the skin into bottle and vase shapes and then painted the backs in different colors. I then adhered the skins to my gesso-primed board and painted in horizontal lines with Fluid paint.

Applying Layers of Paste to Create a Landscape
with Patti Mollica

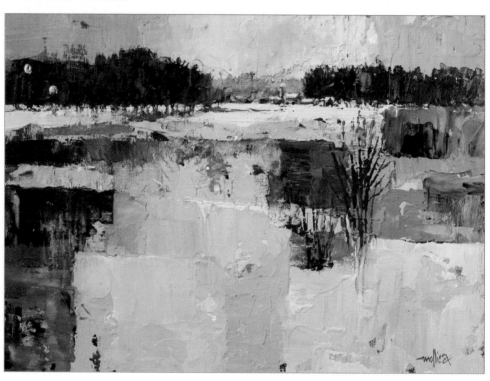

Country Fields • 16x20" Acrylic on canvas • By Patti Mollica • www.mollicastudio.com

First I painted my canvas with dark, earthy shades using Heavy Body paints. When that dried, I mixed Fluid colors into Light Molding Paste, Coarse Molding Paste, and Fine Pumice Gel. Using a palette knife, I applied the tinted pastes in a patchwork pattern. I applied the trees using a mixture of Light Molding Paste and a dark blue Fluid. I used a thin liner brush to apply the finishing touches and the foreground shrubs.

Dripping and Stamping

with Ethan Boisvert

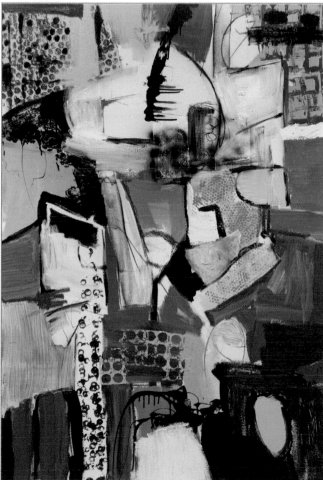

Rabbit
48x72" Acrylic on canvas
By Ethan Boisvert
www.ethanboisvert.com

I started by drawing a loose gestural sketch on my primed canvas. Using Fluid paints and acrylic glazing liquid, I applied broad translucent glazes of color over the entire canvas, which left the underdrawing visible. Using brushes, stamping tools, bubble wrap, and other objects, I filled in areas of color with Fluid and Heavy Body paints. For variation, I sometimes mix High Solid Gel (Gloss) into the paints to boost the shine and add dimension to the surface.

Letting Fluids be Fluid
with Hilda Epner

Head of State
19x26"
Acrylic Fluids
on canvas
By Hilda Epner
www.hildaepner.com

I started by picking Fluid colors that matched my mood. I squeezed them onto my surface, letting them drip and ooze. I used GOLDEN Fluid paints for their low viscosity and strong colors. I covered my canvas with drops of paint; then I tilted it up and down, turning it at various angles while allowing the paint to slowly move in different directions and mix in unexpected ways. Sometimes I moved the paint around using brushes, putty knives, and other tools.

Using Molding Paste with Stencils, Sgraffito, and Transfers

with Melanie Matthews

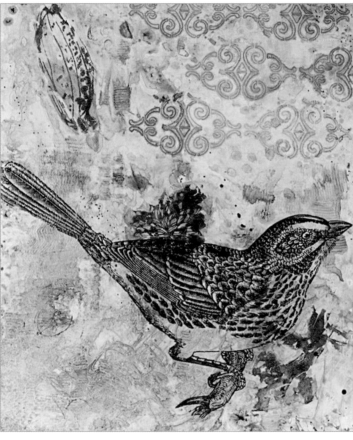

Ornamental Bird
20x26"
Mixed media on
Yupo paper

By Melanie Matthews
www.melanie-
matthews.ca

To learn more about direct transfers, visit www. goldenpaints. com/artist/ directransfer. php & www. goldenpaints. com/artist/ geltrans.php.

I first applied Molding Paste to my surface with a spatula, using a stencil in certain areas, and scraping into the wet paste using the sgraffito technique. When it dried, I used a brush to apply highly Fluid and Airbrush paints extended with Polymer Medium (matte). I then spattered the paint and removed color lightly with rags and sponges. I then made a direct transfer of a bird using Soft Gel (Gloss). When I finished the transfer process, I adhered the design with Soft Gel (Matte).

Explore • Create • Play

I hope that by reading this book and learning about acrylics, as well as seeing a few examples of artwork created with paints, pastes, gels, and mediums, you will spend some time exploring them. What you will find is that there is no substitute for the experience of working with and learning about the materials on your own. Books can help you get started by explaining the properties and characteristics of the various acrylic materials, but the real "I-own-this" knowledge comes from rolling up your sleeves and getting the paint under your fingernails—blazing (and glazing) your own personal trail. This trail is thrilling, mesmerizing, unpredictable, and rewarding. I promise, you are in for the ride of your life...Enjoy!